CW00340964

DON'T BE SO...

DON'T BE SO...

Paul Fryer

Illustrated by Damien Hirst

With a foreword by Harland Miller

A Trolley Publication

Hackney Wick Venice MMII

For Abigail

CONTENTS

LIST OF PLATES

All works by Damien Hirst

THE LAST LIVING KILLJOY ON THE PLANET

Some days when there isn't much between lying under a thin sheet and calling out a priest, there is _Don't Be So..._

I first met Paul Fryer at the opening night of a New York-style eatery in the East End of London. I arrived late, everybody was sitting, smiling, chatting, getting on fine – at least that's how it appeared. You know how it is when you turn up late to a busy place. Waves of restaurant noise break over you as you enter. Inside chaotic rhythms carry on before you – regardless of you. There's a sense of being invisible. Faces, snippets of conversation, a woman's laughter – nothing to do with you. I had no money and I was wearing ill-fitting shoes. I was just thinking about turning round and leaving when a maitre d' snatched up a menu and indicated an empty place at a table in the far corner.

I followed, because more than anything just then I had to get off my feet and relieve the pain of my shoes rubbing at the back of my heels. Close on the table I realised in contrast to the general hubbub that everyone here was sitting in silence. I couldn't hear it at first, but it was obvious from the attitudes and expressions of the six or so people round it that the silence was awkward and that nobody had a mind to break it. The woman I sat next to was examining the ceiling, like it was the Sistine chapel or something. Someone else was inspecting their nails in an off-hand manner.

First thing I did when I sat down was ease my fingers into the back of my shoe. As I bent down to do this I saw Paul. Black hair, moustachioed and a heavy-duty black leather coat buttoned all the way up. I marked

him partly out of contrast to the light, tinkling way the table was set and the bare-shouldered woman next to me massaging pearls into her throat. From this lady's place setting it was obvious she'd ordered the steak and, as she looked around at the décor and everything, I surreptitiously folded her knife into my napkin and on some vague premise disappeared below the level of the tablecloth.

I took a deep breath then stuck the point of her steak knife into the large blister on my heel. As I used my serviette to soak up the fluid that leaked out I heard from under the table the muffled sound of someone speaking. It was Paul speaking or, as I didn't know who Paul was at the time, it was the person I later came to know as Fryer.

When I surfaced he was leaning into the table, leaning into the silence that followed his speech. Seemed like he was trying to catch someone's eye, and by doing so, I imagine, elicit some reaction to what he'd just said, some reaction not at that moment forthcoming. His head moved enquiringly, cocked bird-like. He looked at the man opposite who leaned back in his chair and tried to catch the attention of the waiter, then at a bloke decked out in Prada who made a big deal about the food taking ages to arrive. Then, just as I was attempting to return the woman's steak knife, he looked at me. His brows lifted questioningly and in my distraction I shrugged and said "I dunno mate, I'm in pain."

"*EX-ACTLY*", he exploded, "*THANKYOU*... at last", and he began a round of applause that no one else joined in with. He held a hand out to me as though I was just leaving the stage with my Oscar, then sat down, then stood up again and took his coat off. I didn't know what to

say so I nodded. The woman with the pearls looked at me suspiciously. I was still holding her knife.

I was reminded of this incident when I read one of the poems in *Don't Be So...* called *The Empty Set*.

Never confessing
Their comparisons
With emptiness
Defined by what they're not
Kitted out down the Prada shop

Dylan Thomas in a bar, talking to someone at the bar, said something to the tune of: "Yes by all means tell me about your childhood, but be quick or I'll start telling you about mine." I've always liked that little interchange; beyond the smack of self-obsession it seems full of the intensity with which he experienced his boyhood in Wales, the power of which he then kept close to hand as a kind of anchor amid the booze years and the stints in America.

Personal histories help plot the past up to the present and so to some extent (especially for a writer) create the future. Without frames of reference the struggle to recall can be like swaying up the aisles of a series of grey, unconnecting carriages, pushing in the opposite direction to that in which you are being taken. Landscape rushing past on a blind spot. Blurred passengers. Who are they? Them! Only the people that made up your life – that's all.

Although memory isn't the presiding theme of Fryer's work there is that same Thomas-esque intensity with which he experienced his own childhood in Leeds that comes boiling over in the impulse to write about it; as in *Northern English Sixties Baby (Part One)*.

Which is a good place to start. It's a what? – a portrait of the artist as a young misfit I suppose; regionalised and condensed. Like me, Fryer was born under the sound of the 60s Big Dipper that would soon be steadily grinding to a halt.

It seemed awareness began with the 70s really, the era generally acknowledged as a downer and proof that the idyll of free love (which hadn't reached Leeds anyway) was all a lie. It was time to get your nose back to the grindstone – if it had ever left, that is. Uncertainties of work in a three-day week were distilled into a household gloom, irritation, or reckless drinking that appeared eerie on the face of your parents when lit by candlelight during power cuts. Black hours playing board games with paper money, buying houses and hotels all over fucking London. I never saw the joke back then.

But Fryer was getting himself a good education because he hadn't – according to his poem – hidden his natural aptitude, though he probably would have done if he'd but known.

I never wanted to win favour with the older generation.
It all backfired quite appallingly
as one day I was streamed away
from hard-won friends

in what seemed to be the first of my ends.
I'm still not sure what grammar means
(As I'm sure by now you realise)

The 11+ did separate friends and neighbours but it really was
thought of as the only way of getting on back then. Like 'free love',
'free enterprise' under Thatcher was slow to reach the North and job-
for-life paranoia was fostered amongst teachers and parents. "You can't
do that" or worse, "what do you want to do that for anyway?" – alluding
to anything like art school or languages – were phrases that seem
quaint now but served effectively to confirm for some what they'd been
conditioned into thinking all along. That they were ...

Classed as factory fodder
no one even thought about the chance to be a doctor
to work in silent air conditioned platforms
White in the sky

or that

... pride was something felt in the allotment
or at the fair or else it came before a fall
Or not at all.

If a good education wasn't to hand, like boxing, snooker or soccer, music

(via art school) could also be used to transcend your circumstance. During the 70s and early 80s music had a rich lyrical orientation that reflected or precipitated the changing views in society towards drugs, sex, the ruling class. Even doing sex and drugs with the ruling class, and that peculiar meeting of working classes ascending, and toffs slumming it. Like The Who, confirmed hard men who were going to parties in country houses in parkas emerging wearing paisleys and singing 'I can see for miles and miles and miles and miles...'

All such cultural determinants can be read in Fryer's work in some way or other. I could say especially the sex and drugs, but actually these areas are no more prominent in his work than love and sober reflection. Art rock aside, when Fryer left school, though art college was an option, he went more or less straight into music. Besides, academia was attached to the adult world that had just taken young Fryer's father, and as such it seemed tainted with that seemingly pointless death. Being in a band still represented rebellion and freedom at that time.

I always remember he had amazing recall of song lyrics (still has) which, like verse, he can quote freely, but he never confused the two. It strikes me now that his understanding of how lacking even great song lyrics can be without music created an awareness in Fryer of the job words alone had to do in keeping a musicality and rhythm in his own poetry. Something which he achieves seemingly effortlessly, but more likely as the result of rigorous revision. As Joyce said of *Finnegans Wake*, 'whether you like it or not it's music.'

I'm reading these poems in manuscript form. I'm not sure what the

chronology is, whether it has some sense of linearity or not, but looking back (from a writer's angle) the 80s were coming. Coming to seal my/our youth in a time warp of references towards hardship that people still find peculiarly funny and simultaneously sad. Actually I'm one of them, though conversely past naivety was what allowed so many corrupt attitudes to form and rise like the National Front and ill-advised inner-city motorways and tower blocks. Quarry Hill – there's a connection there somewhere. By the early 80s experimental town planning in Leeds had really failed the community. Something about this English phenomenon of 'all change' after the war, 'homes for heroes', false teeth and bright, coloured Tupperware over best Crown Derby, always makes the past seem more poignant to me.

In the resulting urban sprawls the conspicuous inability of the proposed beneficiaries of these schemes to fit in with them is a touching sight and has perhaps informed the intimate tone in the recurring theme of our wars and the civilian aftermath, as in *Grandad On Convoy Duty*.

And when it was time to go home
Who could know what that was like?
Half cut with a loaded gun
Dragging the U-boat with you
And the house as cold as a girl
In a foreign port
Children you don't see anymore
Who don't know you anymore...

And

Deliver us from danger, from the storm
I just wish we could all go home
Together and be free of this for good.

The inclusion of work like this gives the collection real breadth and, uncharacteristically of much modern verse, variety fans right through the book, unlike some poetry which makes you think "Hell, only one type of shit ever happens to this person". Maybe it does, disproportionately, but everyone gets a hold from time to time, a nudge or a winning line. There are lots of good days in this book: good days, good hours, good moments. Like comedy, euphoria or just contentedness is hard to put across, and even when done well it's rarely ascribed the gravity that misery gets. Happiness! Nobody wants to know. Fryer doesn't really truck with happiness as such, but the abstract joy in a poem like *Running Dogs* is imbued with something like a superior kind of sensibility that, as the French say, 'takes my head man.'

Running Dogs hits the ground running and carries on gathering. Each verse speeds without hint of human breathlessness. Carries on with a downhill velocity sustained by alertness to the rhythms of chance and change to something good in the air. After the hillside the barefoot on warm tarmacadam is such a sensual and lean evocation of freedom that it's as though it can't be trusted to humans, and ends up lolloping and canine instead.

There you go anyway, it's one of my favourites, which is sort of meaningless, except that perhaps it's not really one of my favourites at all, just one of the more unusual poems in this volume. It also sharpens the contrast with poems like *Flaming Hoover Bags*. When you've just come down from the hillside, entering the fast food section of Sainsbury's makes Sainsbury's more like Sainsbury's than ever. Fryer often takes us with him, tells us how or what he's doing. Not to elevate the mundane, only when boredom activates a line of inquiry, as in *Music For The Deaf*:

Hi!
I've taken to
watching tv with the
subtitles on
ceefax

Thinking about music for the hard of hearing, hiring hands to pinch him when feelings evade him, going to the butchers for a pound of flesh and sewing it back on.
Perhaps it's a good day after all when past the age of 35 you can face depression, shortcoming and death. A day when it's backed off, a day when you can write *Good Old Death*.

On whatever day it was, the year 2043
Old thingy lost his battle with cancer

Or was it fags;

Then follows a thesaurus for the long Siesta, followed by

And that was the day before me
And I never knew what hit me
& you don't get these inklings
Posthumously

Subjugation by pentameter, etc, is something I've experienced quite often,
so I can't help but have a greater appreciation for the way in which Fryer
is able to land a theme and make what he's saying sing through. Not let
poetry get in the way. Sustain the idiom. See it all the way through
without flinching, as in the poem *Terminus*, about cowardice. Never an
easy one to face down – except that even ignoble poetry is always heroic.
A duality in a journey's end arrived at by the wrong route.

I wanted to follow him
as he left the old estate
past the burnt-out cars
and the concrete traps
some kids were smoking
and just as I fled
they followed him instead
they wanted his money...

and into

I sort of hanged myself that day
when I turned and walked away

nobody ever knows the pain we feel
especially at vain regret

And so
I caught the next
and ended up
at the end of the line alone
crying as too tired I tried to write
my squeaky excuses on wet metal
with my empty indelible pen

As I've just re-read this foreword to here a voice in my head said
"...you're tuned to Harland Miller and that was *Terminus*." And I guess
in some way I do feel a bit like an annoying DJ, interposing and talking
over the intro to a favourite song, then fading it out before the end just
to tell you what you already know.
The reason I've just re-read it up to that prior point is that I'm looking
for an ending, though I suppose *Terminus* could be just that. I only
hesitate because I feel – no, I know, I've hardly touched on all the
subject matter compacted into these pages.

Perhaps the ones I've mentioned don't even give a very good general picture and I'm trying to swing it back to the poem that gives its name to the title of this book. *Don't Be So...* Maybe I shouldn't be.

Addendum

11th July: Hyde Park, Sunnyday. According to an *Evening Standard* headline behind one of those harlequin paper traps, smoking pot is legal now – sort of. Some journos were out looking for emancipated users. When they'd gone, a group of Italians offered me a spliff and made a big thing of getting on their backs and loosely gesticulating at the clouds, spouting some nonsensical Hendrix.

I followed suit, at least I lay on my back, more because I don't really smoke pot and it made me feel ill, but, after a bit... *back when the world was young a race of creatures long since gone...* came into my head. It's the opening line of a poem from this collection called *The Cloud People*. Although my mind was partly stultified by weed I realised then over the weeks and months I'd had the work to read just what a good companion this volume had become. And that perhaps it's real value, and the value of all great poetry wasn't just in reading and analysing it but more in moments like these, and all of these moments yet to come.

Harland Miller

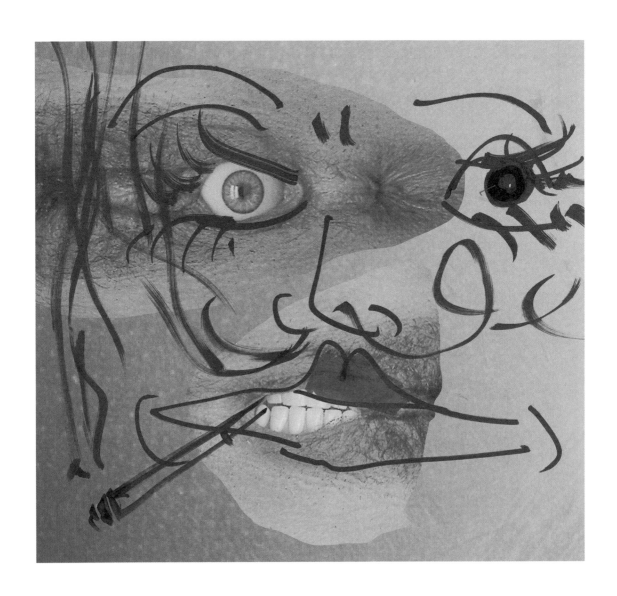

SWINGING TACKLE

Smoke exits thru your mouth and nose
A drink moves to your lips
You tempt me with your panty hose
Your bum and tits and hips
And talk of chains and whips

Capodimonte Flowers
By the portable telephone
You pick it up and whisper
That your husband isn't home
(that repulsive little gnome)

Those Betamax cassettes of you
With not a stitch left on
Cavorting with a teenage boy
Won't play on VHS
(perhaps it's for the best)

Your lips are glossed-red rubber rings
Your face a rusted iron shack
Is it any wonder that
Your husband had a heart attack?
(He won't be coming back)

The Vauxhall squats on patio drive
This used to be the showhouse, kid
There's pot-pourri in the downstairs loo
There's Sandeman's and whisky too
It makes me think of desperate shags
And abbreviated ads in contact mags
Of tissues in bronze bedroom-bins
And films with Robin Asquith in
Of caravan parks by dark grey sea
And macaroons, bright orange tea
And chipboard veneer home-play organs
With built in Bossanova patterns
Originally bought from Grattans
(As, I imagine, was your underwear)

It's gag awful.

OH MY LOVELY MUSE

Is this just another ruse
To trick me to believe in you?
I am so unkind
With my old suspicious mind
Watching for the treasure trove
Hiding in the smuggler's cove
Of confidences, lies
Where only bats and time can fly
But oh my God, your lovely eyes...

How many times do I have to see
What's there, what's right in front of me?
We shuffled around beauty
Transfiguration
When one another's face changes subtly
Perhaps becoming as it once had been
As if the heart and mind combined
Not separate like we

But no matter how hard I held you
Curled up like a frond
Or how hard I prayed for merciful death
Or how hard I drew your lovely breath
– second hand
Your mouth absorbed my kisses
And it seems I've lost the rhythm
Of the beats that my heart misses
For the song that was not was not done
As we parted
still alone

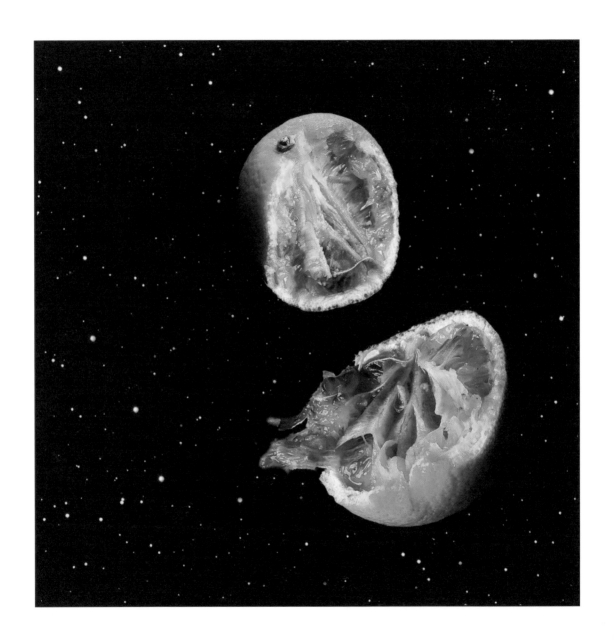

BLOOD ORANGE

It starts like double maths
Monday morning with no excuse
Being fought and beat, getting caught
A foetus in your first boiled egg
Making the next unthinkable
Standing in sandals on fresh-laid dog do
Arson in a northern schoolyard
That frigid's violent Irish brother
Blood orange

It's not fucking fair
Like a tetanus injection
Or the laugh of a girl in front of your friends
A bad hair cut on the first day of term
When the chain comes off your bike in town
That cross-country run in the pissing rain
A nasty throat infection

They say that pride comes before a fall
But I can't help being proud of you
So where does that leave me?
It's just not fair
Like bad reception
A Monkey's Paw-type resurrection
With only half a head left on

Hello, mum, it's me! Your son!

I'm caught within the icy gleam

Of dead perfection's stasis beam

Staring at a handful of dirt

There's puke all over my hair shirt

But I'm fucked if I'm taking it off

If I could move, I'd separate the white from yolk

Triumphantly to prove

In vitro what a chef I am

On kitchen pipes to play like Pan

A regular all round Renaissance man

A bloody fucking genius

Observed in my mind's eye

The blood-shot orange rotates

Like the lightly-pocked surface of Mars

Rapt, a black backcloth

The stars showing needlepoints

Allowing the flare of

Heaven beyond through

In some places more than others

Something like a shrunken

Threadbare suit

Meanwhile, on the other side
Of the luke-warm orange
That we call the sun
On the doppelgänger Earth
Revolution has begun
I lean with key on my front door,
Not sure what I am pausing for
Just as the other me falls in a hail of scorn
Convicted traitor before the firing squad

I push my finger into the pith and part the photosphere
Aerosol sprays its prominence into empty space
The smell of citrus stings my face
Like far-away Spain
Warm domain
Of blood orange.

THE SIMPLE LIFE

The urge to prune my life
Hushes past the curtains
And gently-sudden
I am teetotal
Rooming with a family in Greenwich
Professional N/S
Mousing through Sunday crosswords
Learning chess theory
(bridge being too gregarious)
Finding symmetry in Radio Four
and wireless cricket coverage
chesty and short-sighted
Love being unrequited
Adventure a trip to the library
In the rain

But I have no maiden aunt to visit

No Bakewell tarts or antimacassars

In my deranged family

first generation

Bog Irish and tinkers

There's no church for me to visit

For any will do and I can't seem to care

In which one I flare

Which I do from

Time to time

A Catholic Roman Candle

Burning at both ends.

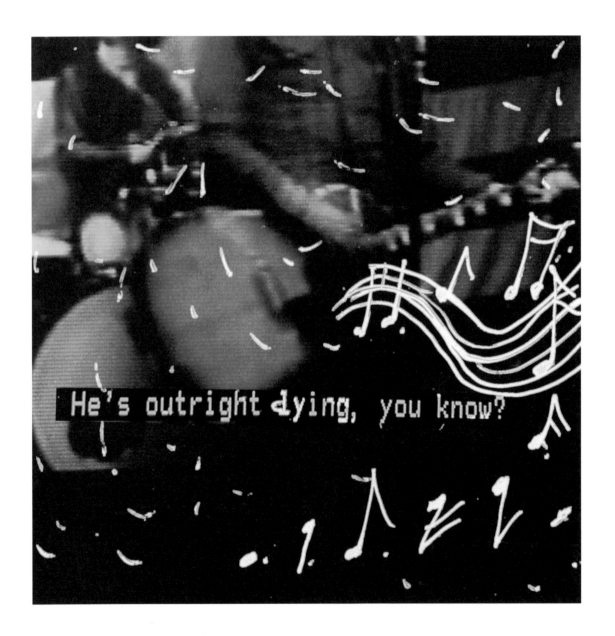

MUSIC FOR THE DEAF

Hi!
I've taken to
watching tv with the
subtitles on
ceefax

Perhaps some
subtleties are lost
but others are created
the truth creeps in
where I never saw it before

As I watch
a pop group pitch and lurch
past their own silent words
bannered beneath them
I think about
music for the hard of hearing
pictures punched out
perhaps in Braille
tears in bottles for the lacrimally barren
and hired hands to pinch my own arm

when feelings evade me
to keep it all neat and tidy
like going to a butchers shop
for a pound of flesh
and sewing it back on.

DIRTY WORK

Waking like any other day
I take coffee
and stare from the window.
You hide in the garden
face a red mask
eyes gleaming white
against the blood.

The trees shiver.
Suddenly it's winter
I wake like any other day
try to talk to someone
on the telephone
the mediocrity is a sculpture
towering Serra
it's going to be slow today
(the traffic I mean)
and downstairs in the hall
unseen you work
teeth white against the contraflow of red
cutting with determination
at the corpse

Baselisk
toying with a bird
why don't you kill me too
and get it over with
your face is human as you regard me
anthropometamorphosis
your weird eyes

A million tears fall and
For each is folded a paper crane
for rights that cannot be wronged
for lies that cannot be corrected
for a world of trouble.
I take my hard-earned wish
and downstairs you are sleeping
as I slip from the house unseen.

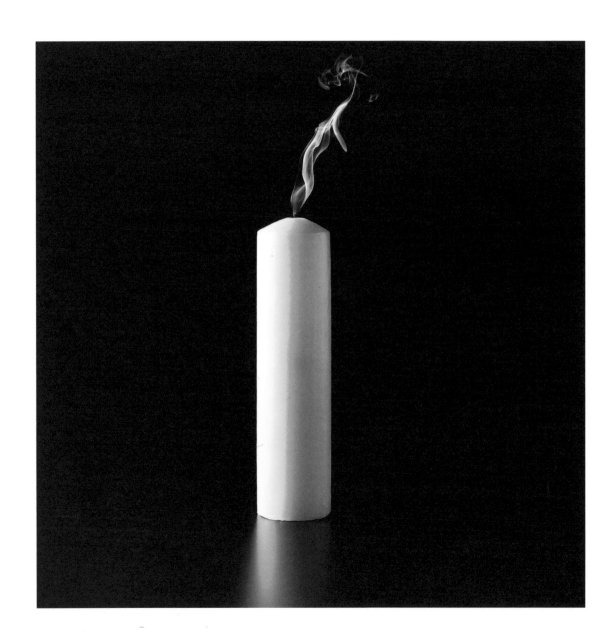

THE TRUTH

Here is the truth.
I hope it sets you free.
You live on a spinning ball.
That's all.
It makes me laugh
You say God doesn't exist
And then chide me for having
No sense of humour
I say
If He doesn't exist
Then what's there to laugh about?

You live in a corduroy world
With elbow patches
And diminishing returns
Oh, and your prickly fear
But it's still a spinning ball
Explain it all away in terms of
Physics and accident
Photons with a random bent
Little carbon copies, clinging to the crust
Subatomic sneezes, coughing up the dust.
Meaning fails before your faith in nothing
Life is just a joke
Without a punchline

Death, an idea
Without a lifeline
Until someone dies

I say good luck to you
You've already set out on
Your day trip to oblivion
With a charabanc full of realists
Logarithms chanted over the clunk of the wheels
On solid ground provided by hollow providence
What a pile of raw coincidence!
Focusing together
You'll be able to see it all for what it is
Nothing,
A letter zero chalked on your
Dean & deLuca lunchbox.

GHOST CAT

I saw a ghost cat yesterday
He was white as in life
With a mark on his face
It suited him more as a ghost
Fitting in with the sky
As he walked the walls
And cast-iron rails
Without fear of falling

He manifested in a puddle
In the corner of my eye
I looked and he was gone
Until I looked away and then
There he was again
I gave him a piece of my sandwich
– which he disdained

I wondered how he ran out of lives
(I think he did too)
Hanging around in the park
In lieu of form
Perhaps hoping to see an old friend
On the bench
Or a ghost-bird
Sheltering from the rain.

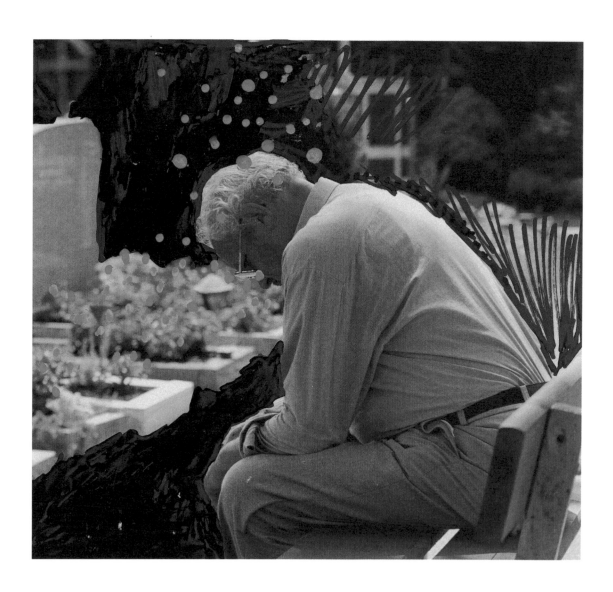

GOOD OLD DEATH

On whatever day it was, the year 2043
Old thingy lost his battle with cancer
Or was it fags;
Anyway, he died
Pegged it
Snuffed it
Kicked the fucking bucket
Croaked
Passed on
Passed away
Passed over
Went to the other side
Went before
Augured in
Bought the farm
Went to meet his maker
Breathed his last
Expired, etc
And that was the day before me
And I never knew what hit me
& you don't get these inklings
Posthumously.

MEANINGLESS STATIC

In the dream there is a railway
I'm often on the train
People get on and off
At the various stations
People I used to know

Then there's the funhouse
It's like a sanatorium
Or perhaps a Victorian spa
Full of head cases
And intellectuals

I know some of them
And we talk
They're never surprised to see me
The curved track of my mental train set
Seems to lead me straight there

It's like the day after a party
When everyone finally gets to meet
And we all end up in the pub
After a short sojourn
On a freezing beach

The other dream I can't remember
And wouldn't want to anyway
Is the kind of dream
That Piltdown Man
Was scared of
In his day.

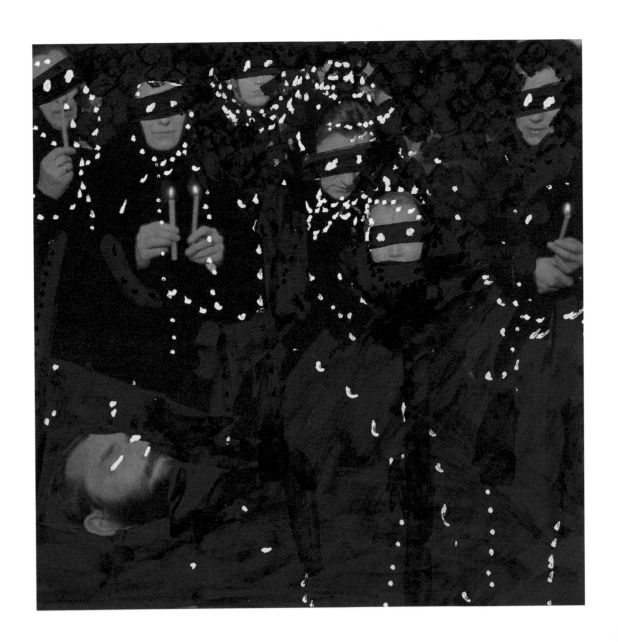

PARADISE ROW

11:15 AM
clouds feint the sky
way above Paradise Row
April showers abate for the pale morning
they gather in dark glasses and crombies
outside the undertakers
an usher brushes his topper
topless tripods crowd the side of the road
today they're putting Charlie in the ground

My car radio plays a song from the 'fifties
Tammy's In Love
nervous coppers ride by near-stationary traffic
it's terrific somehow
another era ends every second
each one stripping back vanities
to wreathes and black ties
to just so many crocodile tears
and elephant memories

The cortège assembling at the kerb
an ageing boy grey-haired in camel coat
Cohiba and flashing gold
says something to the clouds
under his breath

11:16 AM

The car in front moves on

and so do I.

THE SATANIC TRAINSET

God knows where the tunnel leads
but I can see the train
halfway in there
Steaming
its one red eye
regards me with contempt

The track is warped and undulates
I would like to tie you to it
and run away laughing
but you're the fat controller
and I'm the scapegoat

Just one more thing
Universal Terror!
We all have our day
and we all fall from grace
if you don't believe me
check your timetable.

GOD VS. THE DEVIL

He sits as fat as an old dame's leg
Making something new with his dice
Lice for the blighted
White sticks for the unsighted
A bunch of grapes for the faint-hearted
Heaven for the faithful departed
The cathedra throng delighted

Old Nick rests in his chair
And smooths his slick black hair
A satellite caught in the Sun
His mind rotates like a weightless man
And as long as we have fun
His balls stay in the air

C'est La Vie
La Mort, La Guerre,
The bore
Pork all bad books
E-argh Fuck You
Abar Shalla-Walla
Wugga-Wugga
Shh!

Don't move for a second

Listen

For the sound of sixteen hooves

On bloody clay.

THE DESTROYER OF THINGS

What a quaint little shop!
The door has a sign on it that says
'opening hour – one till one'
You're the laziest bastard under the sun
But you can afford it
The one thing you're not short of is money.

Your face imploded long ago
You look like you've been sleeping rough
Selling vacuums door to door
You're rotting
But you still have a go
Still dream of firm young flesh
Your hand clamped on her mouth

The thought of you is like
Putting a screwdriver in between my front teeth
And snapping them
The porcine paws that are your hands
Would gladly do the job for me

I read in a book once
About a boy who slew death
With a sword he got from heaven
On the verandah

In the afternoon
But it turned out to be an old man
He barely knew
It's probably true

You will leave that body when you tire
Slip off, in the form of a fly
But we can't kill you...
Killing is your game
And we can't beat you at your game
You're just too damn good.

Surely the distance of death will afford
Us the definition of all good and evil
As mere points of view
Differing sides of the same coin?
Surely there is no agony perceived
(except by those who watch) when
You gargle on your own blood
Refusing to recant
The limbs torn from your body
A vision of angels dancing before you their
Gentle arms bearing you home.

MONKEY BRAIN DELICACY

Not every day
One hears a new sound
Sees a new thing
Oh how it folds all this life
An origami of flesh
Like the wife who disappears
In Solid Geometry

I watched them dropping
Skulls in the compacter
Making solid boxes of
Cranial bone
They were putting bodies
In the car crusher
Making cubes of flesh
Adding perhaps a dash
Of Lea & Perrins;
A splash of Angostura to taste

Oh the sound
As they pulped those monkeys
The sound of the earth as they
Wrenched off the lid
The sound of one oscillator
As the brain became

An ant's brain
As life stilled to
One final sound

The cortex has no nerves;
Face relaxed
And happy.

IN FORMATION

The sky was leaden, grey
On the day of the flypast
A turbulent day for the Windsor Formation
The clouds had almost dropped to our level
Forming a dirty ceiling on the tonal city
I heard the rumble of the Merlin engines
Six, side by side, shaking the building
And ran out to the roof
In time to see them wavering between the blocks
That pass for skyscrapers here in London
Then I remembered last year
Standing naked in my flying jacket

The next wave passed
An early-warning bird
Disc rotating slowly
And then another
A Tristar flanked by fast jets
With the Canberra bringing up the rear
White and dated
Warbling a little
Surfing the breaking cloud
Bobbing slightly between
The differences in the air
Her pilot straining through

Rain streamed lucite
The black cockpit like
An old, stripped Jag
Leather and mineral oil
Sullen dials
And the sound of her
Shrill voice through the aluminium
Rising and falling
Like the wind in a tower

All those eyes
Followed them from the east
The water like tears on their cheeks
Passing the open camera iris staring
To set with the sun
Like sadness
Patient and
Still in formation.

Bless the Father
of this house
and Bless the Mother
also,
and all the little children,
that 'round the table go.

I HATE HOUSEWORK

The door finally opens and I see inside
A hearth that's burning all my pride
A bookshelf bunched with leather tomes
An embroidered duster, 'Bless This Home'

But beyond the glass in the great outdoors
Where it never bloody rains but pours
The car I came in howls and peals
And burns on bricks without its wheels

And down the road around the bend
That's littered with discarded friends
And landlords that still want their rent
The taxman's picking up the scent

But I didn't want to hang around
The garden path you led me down
Or wait again out in the street
Or let weeds grow beneath my feet

Or listen to you banging on
About the the way things could have been
If we had both been different folk
And I had been a better bloke.

Kitchen noises can't compete
With time, that drags reluctant feet
To the engine room of doubts and fears
That pumps the blood and forces tears

But cellars dark that cork the wine
Are not that great for drinking in
Here apprehension flights a stair
That leads straight up, to who-knows-where

A creaking board above my head
A nutcase with a severed head?
But still I ask for certain proof
I'm going up, on to the roof.

A LITTLE LIGHT SHINES

Dazzling white catoprics
The broken finger of the sand
The smashing of breakers
How am I?

The beginning of my life resonates with the end
How can I die?
When I think, are these the last thoughts
Teetering at extinction
Breaking like water on the edge of
An enormous teacup
It really doesn't matter

God is renewed greater than before in each undertaking
He is uncaring but for his purpose, insane;
A machine
And every time we try to sleep he
Bashes the cage with a stick that's
Long enough for him to remain seated
We start to fight again

We all worship the same God.
He is quite mad.
But beyond the hallucination
The clashing ceremony
Of his distorted greatness
If we outwatch
A little light shines.

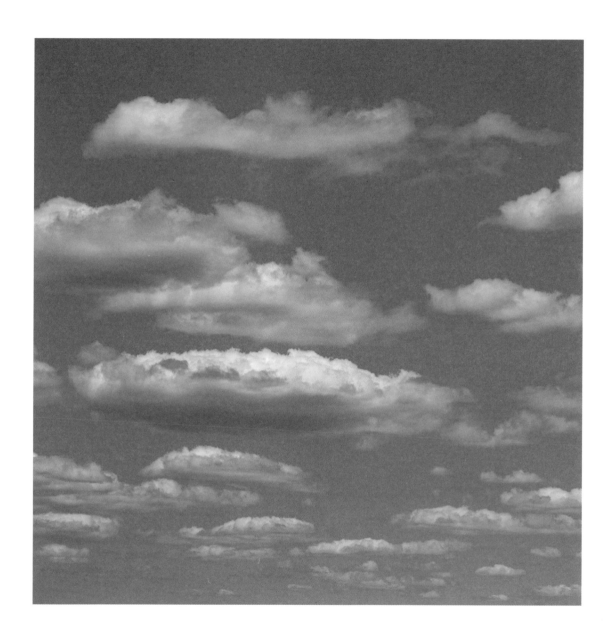

THE CLOUD PEOPLE

Back when the world was young
A race of creatures long since gone
Gave the clouds their form
They had no corporeal physicality
Floating basically free
And now their analogue
Persists in every cloud we see
Like empty sea-shells washed up on the sand
Or fossil light beamed out from the beyond
As individual as you or I
These were the people of the sky

Now clouds float by and metamorphic grow
Observed by us down here so far below
And in increasing numbers from above
On flights of fancy billowing in love
These glowing forms suspended in the air
Will be in some minds now and evermore
An atmospheric memory of they
Who flew up there once
on another day.

HE'LL GROW OUT OF IT

I don't hold grudges
They hold me
But only as tight
As a bloke holds a rotten tomato
Before he throws it
Splat! Got the cunt.

I don't really have lovers
Only friends that I sleep with
'Til it ends in tears
(usually mine)

I don't really get hungry
It's just that sometimes
I want to eat something
More for the bite profile than any vitamin
Glowing in those proteins

And I certainly don't sleep and dream

And not want to wake; and then when I do

Feel the space around me tighten

As gravity grabs me in its tractor beam

And the light prizes me open

Like a barbiturised clam

Who doesn't really fancy breakfast.

Oh, no.

But I do fancy you, though.

THE ILLUSION OF TIME

Soon enough the mystery will be upon us
Slowly revolving
Climbing clear of these silent mouldings
And God-cartology
Those light-consuming singularities
The slow defeat
That grinding time disposes with
That fear suspends
Just before it leaves us free
If we find courage enough to face it.

Please listen with care:
I am fearful as I write
Opening this mystery
Be aware we run behind not time
But something else
Time is gone already
Time is an illusion
All time has flown
Including now
And all the seconds cease as
Suspended in between myself and what, I think
If it has an end, has already passed
I too must be gone before.

I'd best get on, but where?

Where to?

To where, if not here?

And when, if not now?

IN THE GARDEN

Lay your heart on my lawn
In the light of the Sun
Near the seeds that we've sown
That have already grown
By the shade of the trees
With the hum of the bees
It will sit like a gnome
'Til we find it a home

I must have missed the flowers you sent
The delivery man maybe binned them
Rather than give them to the wrong person
But plenty more will grow
From between the weeds and rocks
If we let them

Put your head in my lap
Let's avoid a mishap
Turn away from the grief
Turn another new leaf
Maybe all this will pass
If we lie on the grass
And of course it will rain
But not today.

SYMPATHY FOR THE CREATOR

I am His corridor
An annex
A vitrine that He sees through
The house He comes home to

I am mother of pearl
A shell
Held to His ear
I am a book open
On His sleeping chest
I am exploding inside Him
Inside His eye

When I am alone
There is the watcher
The feeling always
The far away receptor
Silently accepting

I am a line of force
A pillar of energy a
Euclidean arc a
Break in the weather a
Pulse of the bloodstream a
Breath of fresh morning a

Pale horse parading a
Co-ordinate turning a
Torch almost burning
Lesson I'm learning
A memory returning
Woowoo!

THE KINKY TECHNOLOGISTS

There are teams of them
moonlighting from Soho
they wear blackleather
tightening handles, turning ratchets
lowering shiny cases into bays
making notes on credit cards
eyes behind visors

The machines wait on mummy's apron
in futurist green light
then airborne secretly pissing over
a silent re-mapped Europe
loads of glowing screens etcetera
garbled low frequency messages
no food no sleep
the kinky technologists
creepy and effective

No time off now!
curtains of rain
the buildings grey canyons
and in between motionless vehicles
then approaching from the east
a storm of paper

I stare in the shop window
at the circles of dust where the
goods must have been
well who needs food
when you've got security?

Won't you buy me a ring?
Come with me, beyond the fear
into the morning
the messed up hotel room;
we'll sit above it
taking turns at being adult as the
black water laps against
the counterpane's hospital corners.

FOR MY FATHER

We stand
outside the auditorium
now darkened
The carrousel still rotating
The bulb long since burned out
archways, gloomy corridors.
There is no rest for the wicked
or anyone else
A poltergeist whisked the delicate china
onto hard tiles
and shattered
All is now orchestrated
By the conspiracy.

Your virtue
your smile
your hard times
My father's death
my mother's life
my laugh lines
My cousin is an angel, now, too.

And in the lecture theatre
that has now become a church
guttering candles choke on incense smoke

caught in the light of the projector
And the extractor fans move quicker
as Christ's spirit enters in.

Out on the road
like in wings of desire
You lay dying
and all around the wires sang
and telephones rang
and buses crawled,
the three wise men:
Crime, Lucifer, Amnesia.

NORTHERN ENGLISH SIXTIES BABY (PART ONE)

Everyone just wants a chance
to earn a living maybe, procreate
Break the mould set up by faulty genealogy
send an idea barking at the fold
or launch a little boat of hope
upon a sea so misted by the century
just passed

Hair in a bed head
torn tees, scuffed knees
still to be suffocated by
the clamour of our teens
Midnight came just after dark
creeping 'round the darkened park
all was fine 'til we found out about
sex and adults.

Gentle Jesus uh!
Classed as factory fodder
no one even thought about the chance to be a doctor
to work in silent air conditioned platforms
white in the sky
The big glass banks were always someone else's church
where little people didn't serve
but prayed to a pinstriped priest

for one more week of grace.
We astounded who we could in those days
though only one step at a time.
It wasn't right to go too fast
irreverent and gauche you'd bring the wrath to bear
because pride was something felt in the allotment
or at the fair or else it came before a fall
Or not at all.

I never wanted to win favour with the older generation.
It all backfired quite appallingly
as one day I was streamed away
from hard-won friends
in what seemed to be the first of my ends.
I'm still not sure what grammar means
(As I'm sure by now you realise)
but the smell inside my briefcase
I still detect on foreign buses (in the bendy part)
and I'm back inside assembly number one
listening to that strident voice
in my brand-new blaser
a buttoned-up Fauntleroy
second smallest kid in the school.

Which was, like most, falling down by slow degrees
John Poulson had prescribed a method
to save money on the bricks
and we picked up the pieces
in the yard at breaktimes.
Popularity was measured
by similitude
attack wings of vicious sparrows
waited for any
escapee budgies
and that, it was explained,
was why we had cages.

And so the malcontents all took up smoking.
The bikeshed was *der bunker*
where, dug in with incomplete intelligence,
unlikely alliances between
hooligans and artists
that now seem so natural
were drawn up in winter
the dissidents and criminals
hiding in the horizontal rain;

a sort of little gulag
of the brain
and these, they say,
were our best days.

Little faces!
pressed against
the glass as the
screw of school was tightened
where are you now?
Dragged off by the ear,
eaten by work and fear.

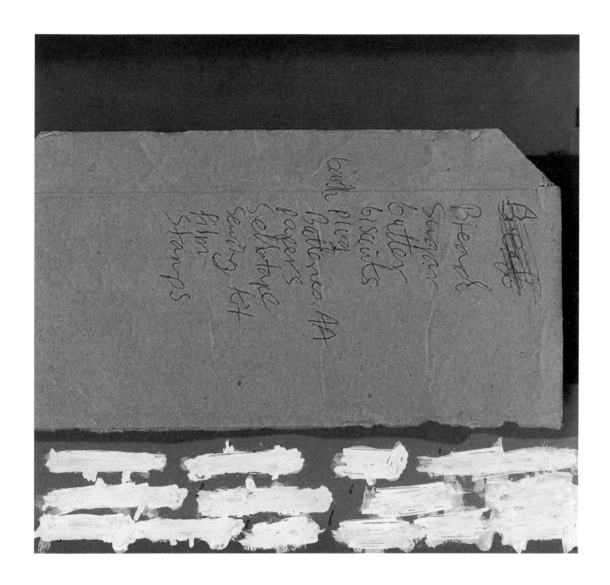

SHOPPING LIST

Bread, sugar, butter
Some wine for my memories
A box of Paracetamol

A packet of chocolate biscuits
A plug for the bath
Batteries for the clock
A copy of The Telegraph
A roll of Sellotape
To mend the photographs
To tape up the stenograph

Some ammunition for my arguments
A sewing kit for when I go away
Film for my camera, process paid,
Stamps for letters not yet sent
And a black umbrella, for the rain
From the umbrella seller
A big, black umbrella.

THE THAW

Mouth parts, a periwinkle
in the melting snow
slow snail
his combing stalks aloft
winter retreating
withdrawing the frosty banner
a sheltering gris reappears
the ululating crop
the crow of dawning spring

In panels of the urban
clocked by meters, trammelled
by rails, solid sheets of stainless light
I am deflected back
to the conclusion
whatever we do
the future's bright!
All seems natural today as
I look for a fast breeder to embrace.

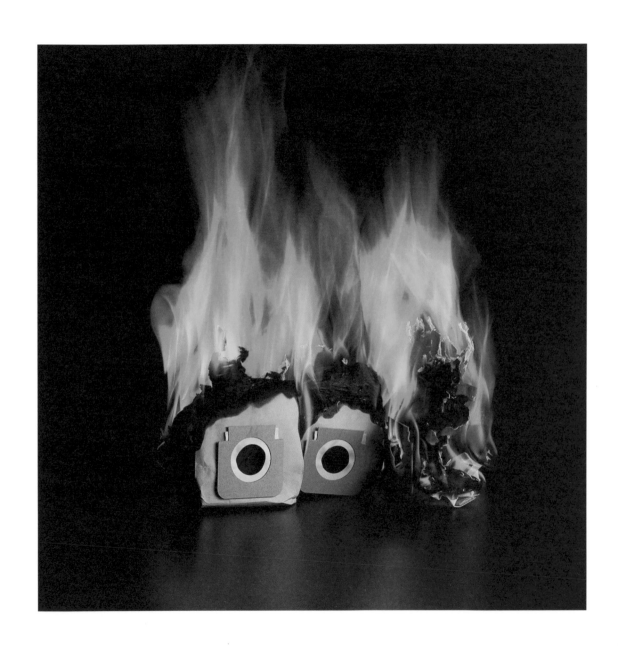

FLAMING HOOVER BAGS

Cheesy as cooked ham
In the supermarket Saturday
I sneak a look into your trolley
And try to tell who you are
By what you eat
You catch me looking

I suddenly feel very self-conscious;
You're attractive but predictable
The *Always Ultra* Nestlè next to the *All Bran*.
Now we're really aware of it and it's quite hard
To look anywhere without looking at you

I decide not to fancy you and do a rude grin.
Someone is arguing about how many items in the
Express checkout
And I wonder how many years of our lives we spend
In the consumer limbo of the queue

Now someone has dropped a bottle of ketchup
The wide bright splash of red the faint aroma
Of vinegar and I imagine lying down on the floor moaning
Postured grotesquely my hair soaked in sauce and
You calling hysterically for a doctor, somebody, Christ!

Outside in the car park a lone trolley begins a solitary camber

Slowly gathering speed, unruly castors flapping, she turns

Rotating like a newly loosed satellite

A sparky clash of wire frames

A car starts, someone cheers

I forgot the Hoover bags again.

THE BIRTH OF THE POET

There is a new poet!
How long was he there before no one noticed?
He's equally blessed and cursed
Well, there isn't much money in verse
It's such a long haul onto the curriculum
The roadside is scattered with burnt-out bards
Postured and charred there, failed pugilists
Casts of Pompeiian actors in beards
Pickled in Guinness and other absinthe substitutes
Dead from the neck up or the waist down
Or just plain dead.

Oh, muse!
The bright orange Penguins
Have already turned brittle and brown
Withered like mouldering fruit on the vine
The must of old books is an aphrodisiac, some say,
Young girls used to queue there and you always knew
It was your head that they wanted to fuck
In the absence of serviceable cock

Please come to the reading tonight
We promise not to get tight
And we'll try to remember, of course,
That sobriety is no excuse for gratuitous use

Of four letter words
We all know the lie of the land
A language that's built upon sand
The poetry house is a slum
The tenants are weirdos who live with their mums
All washed up and banking with art
As a job for life – the poet laureate of the dust cart

Yes, career makes them all in the image
Of Ginsberg's heap of 'first thoughts'
Discreetly stashed with the coke cans and butts
And collected by state sanitation
In noisy nocturnal removals
To rise through the ranks of despair
Belching and stinking, just so much hot air
From another rotting Baudelaire.

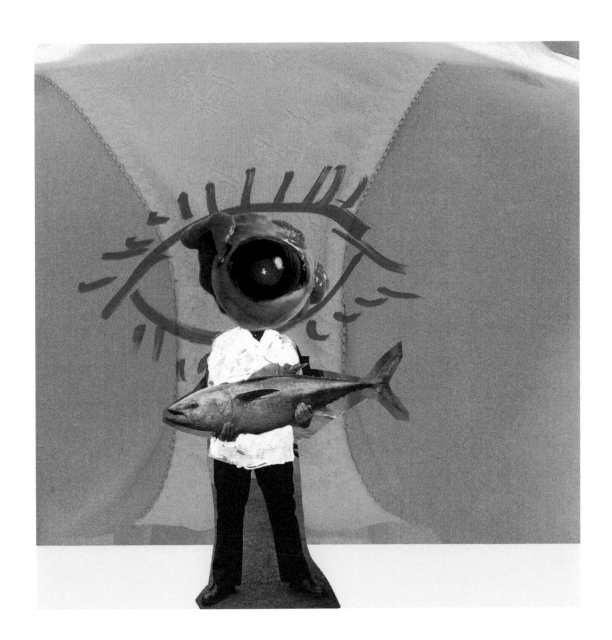

ROVING EYE

One day my eyeball found some extra torque

Popped his socket, went out for a walk

Patrolled along below the ankle level

Ignored coercions there to see no evil

As being quite unfair

Preferring then to see what's really there

Looked up ladies skirts and down

Some very interesting holes

Barrelled through an air-conditioning pipe

Secret installations there to snoop

Snuck inside a bank vault for a laugh

Saw some somewhat compromising photographs

Belonging to a peer

Next time

I'm going to send my ear.

LATE SUMMER

One day in the summer
There was a conflict of passion
Not destructive
But I couldn't trust the week
Witnesses watched everywhere
With smiles and in passing conversations
I thought it wisest not to speak
Leaving commentary on us
To friends and songs on the radio

Though somewhere inside I grieve
It's great to watch you leave
Walking down the street outside the pub
Poised atop your legs
Your wake a mile wide
And deeper than the sea
The boys bob helplessly,
And reminisce

September's here again
And our fair weather friend the swollen Sun
Is contemplating a curtain call
Tempting autumn and us to divest
But the birds aren't fooled
Swirls of martens are meeting in Dorset
It's great to watch them leave
One last dinner and away over the sea.

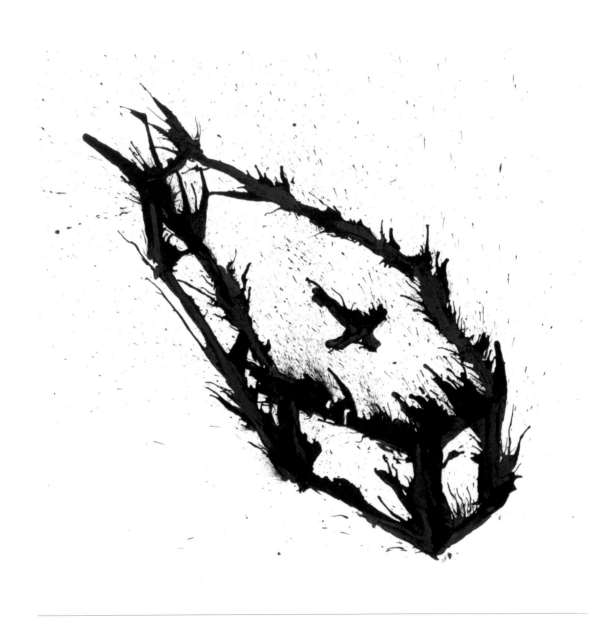

A FALL INTO THE INKWELL

Past the lines of bored salutes
Past the increments of us
I slip suddenly
Into the inkwell
My body dissolved in Quink
Legs first to the Loins
Eating thought and desire
Dissolving the weave of reason
Darkening until there is
Only a hum
Below the millions of tons
Of thoughts, fears and impulses

Dropping now like a stone
The walls become lichen-covered
Flush-made panels of rock
There is a reverberation of the shape
Of an eye socket
Empty space bearing no blood
Ice crystals form
Conductivity slowed
Too low to measure
The bottom has never
Been reached

In free-fall now old friends return to talk

Like burning Tenebrae

In a long-forgotten book

Sense is sensual as

Forgotten skin

The sound of your heart

The calling of the bells

Sunday afternoon tea

A walk in the park

The devastating blow

Of bereavement

Separation

Loneliness

But now there are fireflies

Swarming in the rushing air

a whispering as soft as hair

and I am too afraid,

too cold

to continue.

NON JE NE NANA HEYHEY SAY GOODBYE REGRET RIEN

I'd rather not see you again.
Your face a pearlite moon
in the spoon-backed November night
or, worse, years later
brightest eyes rheumy
camay soft skin parchmented
a satellite picture
of tributaries
hand over soft hair now grey
a mirror in the dark

I love you you know
your face turned away
eye make-up spreading like
blood in the water
and then gone

Here it is again, your name
in the empty room at night
hanging in the air like a banshee
just out of sight but there enough to be
the letters burning in another dimension.
The dimension of time
The dimension of regret
I have none.

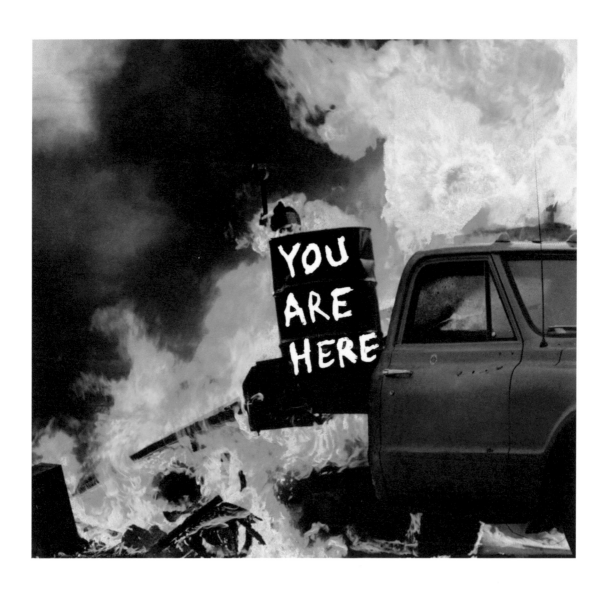

M.S. ON MS. MIRAGE

Oh you move
through me like smoke
clinging to my clothes
stinging my eyes
your hair stacks up
like 45's on a Dansette
you make me fight myself
want to dance.
You've no idea
how perfect you are
right now

I appeal to sense
to the side that might compose
but the order just seems to
turn into elegy; chords rising
from the page
sweeping me up into dangerous ideas
like scent and the way you rest and dress
the way you hold your chest
Mm what a fucking flight of fancy

Maybe I'll always be this way
reaching out in vanity, some might say
when everything I need is

tucked beneath my belt
no one has the right to be so spoilt
loving you and it really is from afar
well it can't be helped.
I just want you to know
that I mean it
before it wears off.

DANGEROUS SPORTS IN BORING WORLD

Speech falters like the lines
Of the queueing dead
The day as dull as a virgin's ache
The night as cold as a war mistake
There is no way to love them

Mediocrity ocean wide but deep
As a puddle forming 'round the severed hand
Of a long dead poet
Who died for what he believed
Recant and be saved!
There is nothing worth dying for, they say
But if you want it, here is your grave.

The cold barrel of a gun stubs
The back of a small child
In the zone of dangerous sports
It seems not everyone has a choice
In the risks they take.
What's left to say?
You don your shades, give the thumbs-up
If you could, would you go?
If only to liven things up?
Please
Next time, put the elastic rope
Around your neck before you jump.

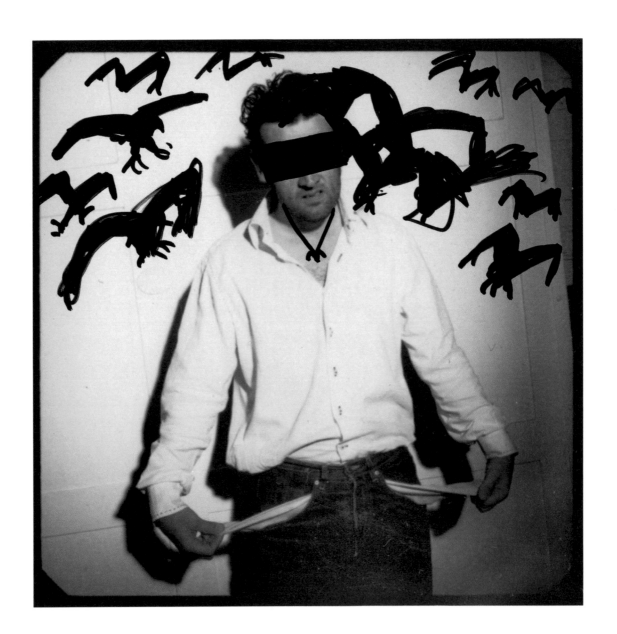

SMUGGLER

Walking into adulthood
I check in obligatory baggage
And saunter through customs
With nothing to declare;

Above in crowded air corridors
Stacked twenty high
The great birds are waiting
For the final approach.

THE EMPTY SET

The empty set
A formless shape
They move across the earth
The doubled cross
Never confessing
Their comparisons
With emptiness
Defined by what they're not
Kitted out down the Prada shop

Deleted again
But still there
Perhaps I'm paranoid
A pattern crawling halucinatory
Over my palms
In the half light
The hideous creeping of electricity
over my flesh
Too close to the generator
Too far from God
Move me, I'm burning!
What a silly sod.

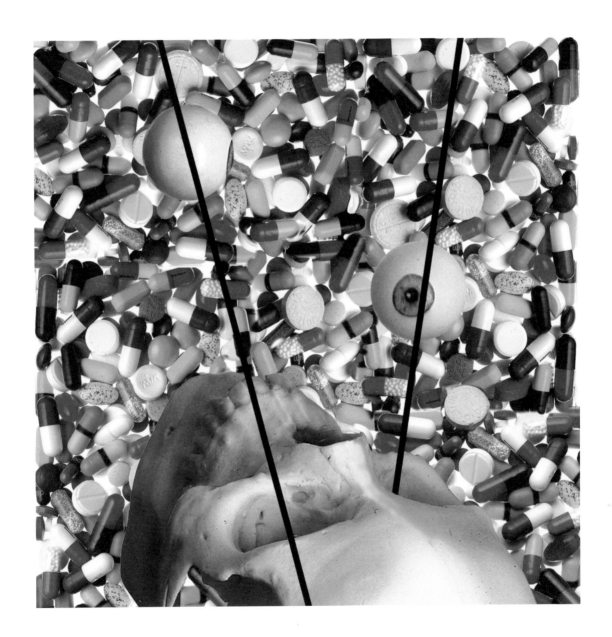

DRUG

My brow furrows
In the cubicle my instant friend
Is cutting at the snowy rhomboids
With a loyalty card from a service station
It's a relief to be
Piped into another solitude
A vista of crystal-clear nonsense
To go swimming at the bar
Sinking through the bottom of my brandy-coloured eyes
Each repercussion flies
And the world rotates just one more time
I don't even notice

It's almost as if I see the glowing button
Purge
& by the time my will finally collapses and I slam my fist
Down onto the panel
It seems I commit all that I have into that action
PURGE PURGE PURGE

2
If you can think of it then someone's done it
Or worse still they're doing it now
Or worse still they're doing it now without me

Next day at the paper shop

I pull out a tenner rolled up like Cleopatra in her rug

Unsteady then I try not to remember

What I already know

That love is the drug;

And I can't pretend otherwise.

PADLOCK HOLIDAY

Receding to the sea
parasols clot the landscape
the heat cutting holes in them
ragged bloody holes
beach security
keep an eye on things

The pedalos tut and shive
shovelling to nowhere
blubber whales beached white
the sun gushing over tamarind
coloured natives

I went back back
in my mind to
Brid one summer.
A man with one arm found me
crying on the sea front
returned me to my one-armed father
I seethed and hoped to die

Meanwhile back in the blue Carib

they sunbathe over

pits full of bones, settlers

hacked off a hand for theft

the pistoleros brand beneath

Jolly Roger battle-stained decks

all consigned now to

the bridge club and

Davey Jones's locker room

with the tennis coach's second-hand plimsolls

stolen by parasite-covered hound with sad eye

more white fuckers

mincing through

Actividades Para Hoy

the television shows MTV

ghetto music for the millions

Murder boils in

a young boy's brain.

Can you blame him?

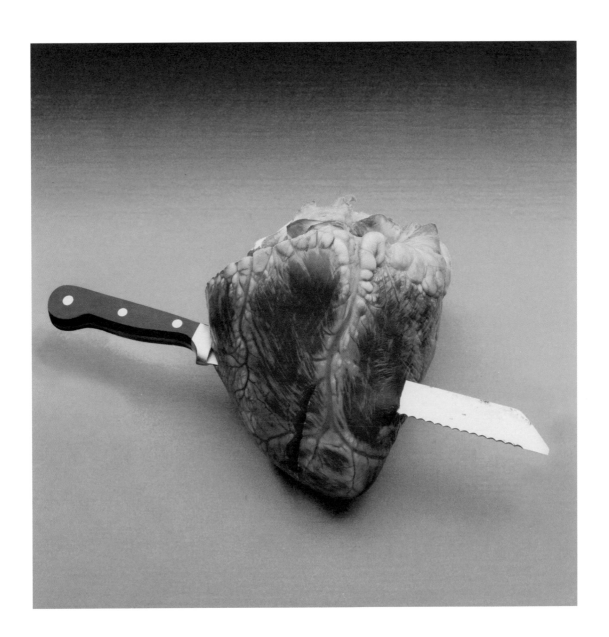

LOVE LOVE LOVE

Love oh yeah
They're making it again
And the walls in the apartment
Shudder to that old refrain

There the ghost of an appointment
Settles on the day like dust
And the memory of losing
Eats into my heart,
Like rust

Moody girl!
Your body is old hat
The unrequited kiddies cry
Just knickers on the line, oh!
You and me
What an old wives' tale we've weaved this year
Like rumours that are born from fear
Those humunculii they multiply

You turn on the television
There's an old friend in a soap
But the character she's playing
Is you when you couldn't cope

And there's friendly opposition
To your new ideas at work but
It's nowt that can't be sorted with
A well-intentioned talk

And I'd really like a girlfriend
Who is every bit like you
Except I want my freedom
And you'd tell me what to do

Love oh yeah
They're making it again
The walls in the apartment
Shudder to that old refrain
Like Dresden
One moment an inferno
The next transparent china
I gave up the ghost today
I gave in again.

EVERYDAY VOYEURISM

You sit every day with your back to me
White trapezium, bra strap showing white
White on white
Typing or something
On the creative team
Your back to the window
Your head in a dream
Your hair in a bob
Doing your job

You can't miss what you never had
Or so they say
It's a shame
It would explain so much if you could
Who is that bloke who sits opposite you
With the blue shirt
Even from here I can tell
That he doesn't treat you well

The milky sky sits with me –
I'm caught between –
They say that pity's the worst
Why do I enjoy it
So much better than envy?
Tea break, is it
On the roof
You and your skinny friend
I'm so glad we'll never meet
It wouldn't seem right

Do you ever get the urge to follow a stranger?
Do you ever feel like declaring your love?
Do you ever feel the need to sit in a church
And cry for the things you miss the most?
Never?

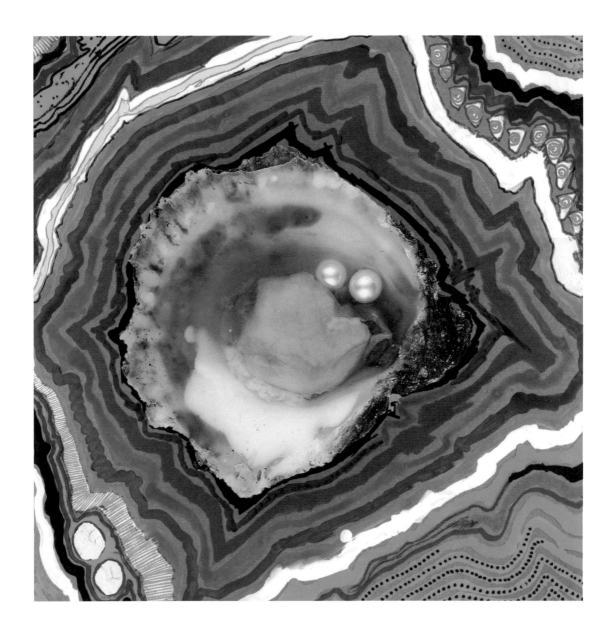

SEX ON LEGS

Sex on legs?
hell on wheels more like
but if the chemistry's right
then the maths don't matter.
Everybody wants you, baby

Spin the bottle
just remember your card and when
I look into your eyes
don't tell me...
you smell of sex to me
posies and wreathes
her will bequeaths

You rouge your lips
and your nipples
sit across from me with
white knicks
just enough on purpose
boiling with composure
I slip into a hellish kitchen and
infuse some tea

I can't concentrate
with all that hitching and hiking.

Were you the school bike?
Did everyone get a ride?
How come I fell off?
Were you the class dyke?
Did I miss out on you?
I missed the day you did it
I missed my virginity too
little miss voodoo.

Oh heck well
it's back to the top shelf mags
to the day when I first held your hand
to the day when I first pushed
myself to ask you
to the day when I asked you
to that day
Goodbye Helen of Troy goodbye
Isabella
It's been murder.
You don't need to ask where I am.
I've had enough of sex and violence
hello, lovely Sunday silence.

GRANDAD ON CONVOY DUTY

Sailors' faces line up like salvaged plates

On the shelf of memory

With only fishes and

Cold grates for company

You old man

Toothless in Atlantic spires

In your sitting duck frigate

And when it was time to go home

Who could know what that was like?

Half cut with a loaded gun

Dragging the U-Boat with you

And the house as cold as a girl

In a foreign port

Children you don't see anymore

Who don't know you anymore

Tons falling vertical to avalanche

The hardest tides, a murdering wall

Of freezing water, stuck there

Inside a day but no light to tell

Numb but to survival and the loyalty

That cannot be reconciled

To dry land

Only your shaking hand on the bottle.

Oh Lord!

Deliver us from hours so dark

Deliver us from danger, from the storm

I just wish we could all go home

Together and be free of this for good.

A MEMORY OF LOVE 136

A MEMORY OF LOVE

Some feelings are shallow
And forever in transit
The tin can light of
a flickering flourescent
We see them as truths
Then find out too late

Others more like background radiation
They resonate with the codes of origins
The after-image of the flash which showed
Our unloved bones in one ghostly
X-ray moment

Do you see what I mean?
Do you know what a long ball love plays?
Arcing over the grand empty stadia of our lives
And waiting to fall
Like little boy
Or fat man
Or the way we fell when it all began
before the fat lady sang

I don't always know what to say
but I do know how to say it
Softly at first

Rising gently to lilt and sway
Folding back into our welling hearts
Warming, rosy
Reliable as a daybreak

Just think of all the times we've passed
That are now only ours
And all the memories amassed
We would never change
And when you do
I'll be there
And so will you
And we always always
Will be.

LUNAR ACRES

A tenure almost in the stars
A square of dust
On the dusky moon
The papers look legitimate and are
It's the perfect gift for
The man who has nothing

There is a golf ball out there
Where birdies have no air to coast or lift
A family photograph
Left by astronauts
One an eyeglobe socketed in the dust
The other a silver halide mirage
They both stare out into soot-black ether
At the gaps between the brush strokes
The space beneath the cosmic stairwell
The pause before the tilt of death

Soprano high I faint and swoon
Billowing out of myself like a flag
Or a stubbed-out fag
a cloud of smoke from burnt toast
the harbinger of
my proper ghost
that something slight
A wink of light
In the happy sappy end.

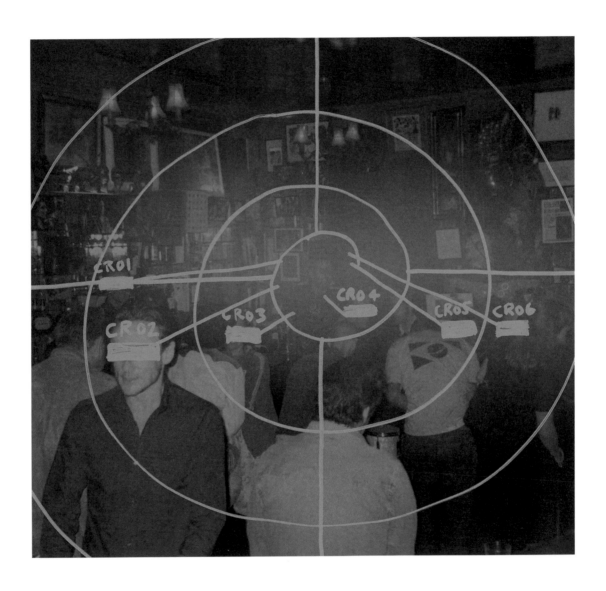

THE COLONY ROOM

time slips –
the crappiness is palpable and green
once maybe it was dance-hall stereotypes
old school queers, lopsided gentry
now mainly archived
old brothel creepers
staring out from frames
a cast of panto dames
the dust fluffed off drapes and tuxedos
settles onto crépe soles
cantilevered from barstools
touching sticky carpet
the ghosts of those cynics past
glower down onto the banquettes
it looks its best from the floor

someone's pushing in through the
crowded door
doubtless after a late dinner
in pied-à-terre
a pie in the Belling
the smoke leaps into the hall choking the
lemon incandescent
like a sick dragon's breath

how are you all?

oh fuck off...Hokey fucking Cokey

the lot of you

has-beens, also-rans

n'er-do-wells

kiss-and-tells

the famous offspring and forgotten siblings

should-have-said-somethings

the drink is flowing

as fast as the senile plumbing will allow

the bitters dissolve in conversation

– we all go below

was that a sneer in the air?

well, see if I care

the room reflects in Michael's glasses

(the ones he is wearing)

I'll be there soon!

I raise my glass reluctantly, honest

the music is Delilah

cheers you cunts.

TERMINUS

Rat started to dance
in his mercantile spats
his cravat rippling silk
his feet flashed
in the bar the young girls
sipped and smiled and
ignored the caveat

He danced out into the street
past slabs of fish and raw meat
winking, tipped a tramp
beneath the old gas lamp
it was just after midday
it was still summer

I wanted to follow him
as he left the old estate
past the burnt-out cars
and the concrete traps
some kids were smoking
and just as I fled
they followed him instead
they wanted his money

I sort of hanged myself that day
when I turned and walked away
I waited for the bus in the rain
nobody ever knows the pain we feel
especially at vain regret
It's hard to communicate
because it's always the same

And so
I caught the next
and ended up
at the end of the line alone
crying as too tired I tried to write
my squeaky excuses on wet metal
with my empty indelible pen.

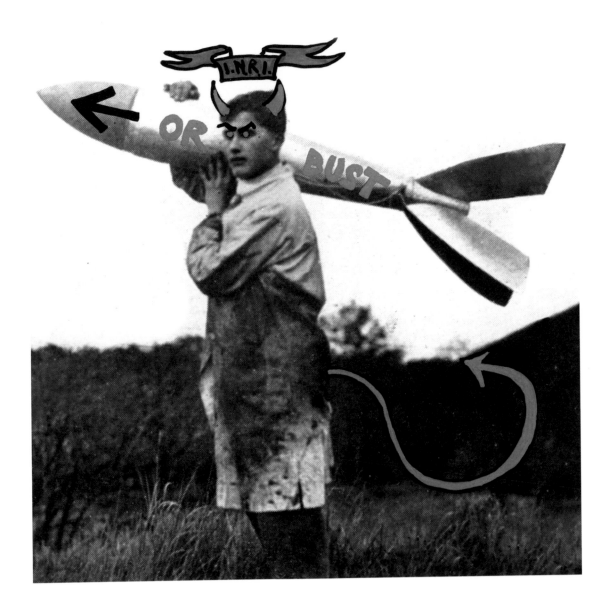

A HOMAGE TO THE ROCKET SCIENTISTS

I watched them land and it changed me forever
And I still ask that question
Like nobody heard it

"What caused Werner,
With one Flash Gordon rocket,
(the state of the art)
Held under one arm
To not stop walking
For one minute
Until he'd put
A man on the moon?"

PLANET HOLLYWOOD

It would be better
kinder by far
if you were to burn up
on re-entry.
Don't land there,
it's a shit planet.

I know
you have to dress up in gear
and pose and swagger and leer
to a hip-hop sound track
And God help you if you're black
you get to be wise after the fact and
die in a noble but futile fashion

The atmosphere, like the plot, is thin.
It contains agents of an unknown nature
which will compel you to speak
like a comic-book baboon
or if you're lucky, dry up like a prune.

The lighting is unflattering
aliens are made on a computer
and marooned there.
They all look like insects
or grannies in prosthetics
exuding Swarfega

New footage!
the director's half cut
the lead's a goon
the starlet's a slut
the producer needs a transplant of guts.
My heel smashes the tape's
skull-like face
drop kick through the open door
They should've given the budget to the poor
Shit Shit Shit
Shit planet.

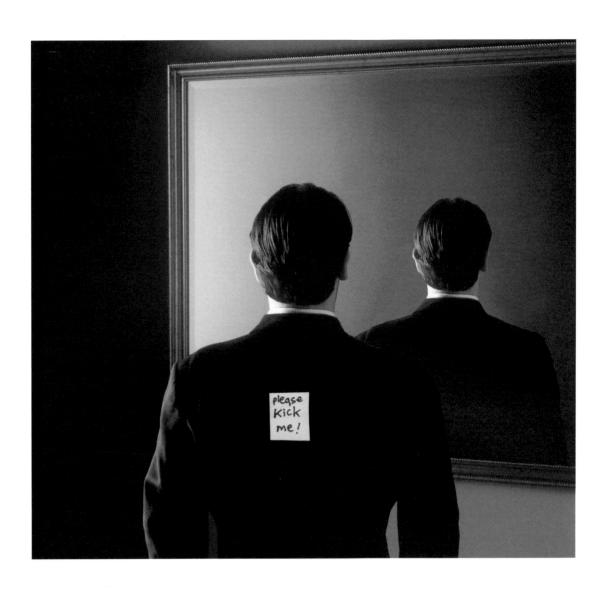

DON'T BE SO...

Fucking stupid intransigent prejudiced politically correct
Faded pound foolish debauched unconvincing desolate
Emotional significantly docile manipulable greedy morbid naked old
Verbal mental genitally obsessed needy flirty matey pally bloated
Ill mannered bad tempered slovenly soppy sly alone
Don't be so stupid
Don't be so stupid
Don't be so stupid
Don't be so stupid
Don't be so fucking stupid.

RUNNING DOGS

Running Dogs
Sun is like a lantern
Low on the horizon
Breaking cloud

Leaping streams
Following their noses
Pulling to the hillside
Barking loud

Rotating helicopter view
Spiralling up from me and you
Panning out across fields of wheat
The air is clear and life is sweet
Tumbling to the ground
With not a soul for miles around
A drop of rain upon your hair
And nobody but we are here

Running dogs
Close into the valley
Clearing over drystone
Break formation slightly

Into town

Echoing through dark streets

Tarmacadam warm feet

Run like dogs.

THE MAN FROM PORLOCK

I had a visitor last night.
I knew him of old
The mysterious man from Porlock
Often mistakenly described as a bore
He'd been to my house before
Usually in the small hours

He spoke sparingly and in hushed tones
But the sound of his voice was unfamiliar
I always forget his intonation, I realised, his accent,
It seemed like the absent speech of a dead person
Evanescent, mercurial, impossible to retain
However well you might have known them in life

He asked if I remembered him and laughed
His knowing laugh, a gentle laugh
And beckoned me to follow, which I did
Through the open window
Out into the night air

We traversed the town together
Crossed the nocturnal river
And silent made our way to his run-down house
I could smell the sea nearby,
And make out forms in his garden
Some great growths of brambles

A few garden-centre statues
Throwing corny poses in the moonlight

We folded into the hallway
His face was neutral, calm as he lit a gaslamp
The steep umbra of a taxidermied animal arched above us
And struck the lintel of a dark panelled door
As if from a bank office, labelled LIBRARY
Strong, square and sure
He opened it, handed the lamp to me
And was gone

Inside was a bit of a shock
Beneath a glass-vaulted ceiling almost too high to see
Mezzanines stacked on parquet in the gloom
Reaching off to infinity
Walls of books without end it seemed
The British Library multiplied by Foyles and then some
And then I noticed the shelves nearest to me (I was in E)
Varying in age and size but all the same edition and binding;
A single word printed bold on each spine.

I looked for a someone familiar and it seemed I knew them all
Name after name embossed on the brown hide
I took down ERNST and opened it
It was a typographer's nightmare

The print size in places infinitesimally small
In places too big for the page
Some things incomplete, words seemingly at random
Line breaks missing,
Plates out of register, perhaps one needed special glasses...
Something was not right
I searched on

ENGLE, EMMERY, EMIN, *EINSTEIN*!
I could not resist and took that down
The great man's book a florid mess of figures
Chopped by disjointed passages in German and Yiddish
Crude erotic daubs. Kilroy was here. Smileys.
Tears falling from a bloodshot eye. A dagger. Oh dear me
Could it be a forgery? Something told me it wasn't.

Behind me a creak, and I nearly dropped Albert's missing muse
The door was closing, slowly, but surely!
The vector of light slicing the dark floor had appreciably narrowed.
Suddenly I thought: I have to find my own book
Perhaps if I could look in there
I could make some sense of the rest of it.

It wasn't easy
I jogged past almost a mile of shelves
The dark opening and closing around me like an eye

Constantly aware of the time I searched,
Staggered at the extent of his collection
At the aeons it must have taken to assemble
I knew for sure Confucius was there with
John Logie Baird, Balzac, Wagner, Attila the Hun
Lennon and McCartney and
Everyone it seemed who had ever dreamed
And many more than I knew, and yet it seemed I knew them all.

I eventually found my annual on a low shelf
A good deal thinner than I might have hoped
I opened it seated on the floor
And there it was.
Transcribed in the time before sleep comes
When we pass like vapour between sea and sky
When the underworld opens to the heavens,
An ancient quarry filled with water of blue-green enamel
Bodies borne lighter than thought
Scintilla playing in the depths unseen
Something short of a dream
Yet somewhat more real...
Every time I'd lost my way
Every lost dream of night or day
Every half-formed and familiar nagging tantalus
Every frustration gathered in one omnibus
And I knew it was of use to no one

Least of all me
As unsatisfactory as a temporary filling

Once I had held these thoughts in my dozing palm
Examined them wearily and felt the thrill of discovery
Despite imminent sleep
Perhaps then I'd reached for the pen several times
But only in my mind
Eventually deciding to wait 'til morning
To transcribe the vision
To record the voice
It was a good job I hadn't bothered
It really was substandard and disappointing
A shadow of what I thought I'd forgotten
The darkness seemed alive then still as
I turned and ran, retracing my steps

It was then that I thought of Coleridge and wondered
About that day in summer when
He'd sat on his lawn stoned in the sunshine
And walked around the Vision in a Dream without leaving
The comfort of his deckchair
There was a time when I'd have paid dearly to read
Those stolen lines. But now I had the chance
It was the last thing that I wanted;
To be further disappointed and besides

The darkness grew deeper by the moment.
De Chirico arches stepped in every direction
I knew I would never find his book in time.

The door was all but shut when I reached it
I slipped through the remaining gap,
As it sealed behind me and
Sliding down the wall exhausted
I heard a laugh. A knowing laugh.
A gentle laugh; my own
Would I remember this when I woke?
For a moment's brief prehension
Remembering seemed to be forgetting.

I slept the rest of the evening without dreaming
There was nothing there for me.
The sure anamnesis came the next day
And I wrote it here as I remembered it
Though looking at it now
I feel sure that something's missing
Although
In the light of recent revelations
Perhaps it's just as well.

First published in Great Britain in 2002
by Trolley Ltd.
92 White Post Lane, London E9 5EN, UK
Text © Paul Fryer 2002
Illustrations © Damien Hirst 2002
Photography by Mike Parsons

10 9 8 7 6 5 4 3 2 1

ISBN 0-9542079-2-0

Design by M&W@FruitMachine
Edited by Thomas Rees

Printed in Italy by Soso

I would like to express my sincere gratitude to everyone who helped with the realisation of this project, whether practically or with their kind words and encouragement.

Jude, Sîan, Claire, and everyone at Science
Damien Hirst
Harland Miller
Hugh Allen
Micheal Wojas
Aaron Budnik
Andy Collishaw
Martin and Wai
Gigi and everyone at Trolley
Ruby Russell
Craig Sargant
Mike Parsons
Louise Fox
Jay Jopling
Katie Kitamura
Lindsay Evans
Natasha Garnet
Leah Brown
Danny Moynihan
Sophie at White Cube
Kathy at Victoria Miro

With special thanks to Thomas Rees for his patience and kindness.